J.M. Creation

MICHAEL JACKSON

What

HIS HATERS don't WANT to KNOW!

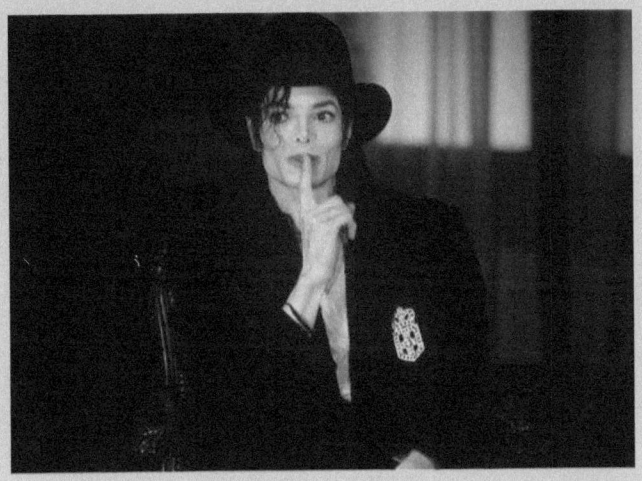

By Jacqueline Marie

Copyrightdepot.com
© Droits d'auteur
cliquez pour vérifier
00047957

J.M. Creation

MICHAEL JACKSON

What

His HATERS don't WANT to KNOW

Jacqueline Marie
©2010

00047957
http://www.copyrightdepot.com/cd2/00047957.htm

J.M. Creation

" Lies run sprints, but the truth runs marathons.

The truth will win this marathon in court. "

Michael Jackson

- This book was written in French and translated into English. Thank you for your understanding if the translation is sometimes rough or wrong.

J.M. Creation

Michael Jackson vs Jordan Chandler is not another book on the life of the star. This book is an explanation of the twisted one sided scandal that surrounded him during the last fifteen years.

Michael Jackson, it's not just music, dance, talent. He is a complex character, who evolved between his passion and his pain.

Those who will have considered him provocative and sulphurous are mistaken about his personality. He was the contradiction of the traditional rock-star, a man perfectly warned about the ropes of the show business, master of his career as much as his art but introverted, locked into a sadness he never managed to surmount.

A man-child, Peter Pan of the twentieth century, hero of Neverland who never wanted to age and created a new world. But also a definite, stubborn man, with firm and thoughtful decisions.

There was two Michael Jackson : the lunar character who escaped from the reality by inventing a universe of fairy tale and the asserted artist, very sure of him, conscious of his power of seduction.

This man was endowed with a "schizophrenic" talent, alternating the matured decisions which built his career with an almost permanent child's game. But to consider that he was a naïve and childish man, it's just a big mistake...

J.M. Creation

To summarize Michael Jackson's public life from his childhood to his term requires some volumes of writing by analyzing every stage of his evolution. A lot of biographers, official or not, impartial or not, got down to this task. But, to dissect the life of the artist doesn't necessarily drive to the man ... The professional aspect of this star only reveals an aspect of his personality and doesn't explain the bottom of his soul. This plan is too simplistic. It's necessary to find his real identity.

The artistic life of Michael Jackson was only a learned mixture of irrefutable talent matched by actor's play with some accents of sincerity. It wasn't deceit. We speak about showbiz and about threads which lead to the success.

Yes, he played a game which built his success. The evidence of a career of 45 years containing two phases, "the race to success " followed of " the humanitarian bulimia ", demonstrates two facets of the character. These aspects, professionals, reflect the intelligence of a hardened man and not the image of a simpleton, as some dare to claim it.

By assuming every decision of his career and politely imposing them, he showed all the strength of a strong character and an unwavering will to touch the supreme success.

And when we know that the whole planet, from the most evolved continents to the most out-of-the-way parts of the country, knows his name, no doubt that he had managed by means of will to become a reference, as he wished it.

J.M. Creation

Here is the man, in all his magnificence, who held the bet to break all the barriers and gather people in the harmony of his music.

Is he silly ? No way !...

Michael Jackson alternated his facets, being able to be also grown-up as a businessman, as child at his moments, relaxing the pressure in the play.

He also suffered from an intense feeling of loneliness, ill-at-ease in front of too much people only interested in his work and the interests it could generate. Permanently sought for contracts or phenomenal placements, he wanted to avoid this too "hardheaded" world which had so quickly changed his name in trademark.

An artist is not a financier, a poet is not an investor ... He quickly understood that his "friends" were interested. And his loneliness grew louder throughout his success.

Getting closer to children was the only way to run away the hypocrisy.

No adult addressed him without ulterior motives - including his family. Bombarded with requests and projects in any kinds, he quickly became a victim of a tempting success. And as he looked for a means to extricate himself from this trap of the "singer-employer", he collided with the extreme, destructive jealousy.

The pages that follow evoke only the Chandler case that broke in 1993.

This case is very often underestimated in biographies. It's nevertheless the beginning of the third part of Michael Jackson's career. It reveals the real identity of the man.

J.M. Creation

Get down to analyze seriously the details of the Chandler case learns to know the man and his terrible complexity in the pain. It gives a more revealing image of this exceptional being who had believed to reach the absolved control from his fate and had to face a terrible stroke of fate.

Because this case is a real detonator for Michael Jackson.

His certainties fly into pieces and his whole life is questioned. Michael represses the child who slumbers in him and only shows a wounded, vindictive but profoundly disappointed man.

During this case, he revealed a considerable part of his real personality.

It's interesting to note his ambivalence : the man burying the child at the bottom of him the time to build his defense in front of the ignominy.

He pertinently knew that this scandal was only jealousy, envies, dishonesty. He already knew these " strange people " who eyed only his fortune. But from there to accuse him of pedophilia !

Michael Jackson vomited the world in 1993.

Michael Jackson understood the monstrousness of his success and the greediness it generated. To defend himself, he had to show who he was really, without subtleties, without deceit.

In this, the Chandler case is interesting. So dirty is, it describes a man struggling to prove his innocence, colliding with a merciless world offering him no chance to exonerate himself.

J.M. Creation

Throughout this case that really will end in June, 2005, at the conclusion of a penal trial directly provoked by the assertions of 93, the real personality of Michael Jackson comes to light.

In the grip of the doubt, the anger, the revolt, the disappointment, the discouragement, the dejection, it shows his pugnacity as much as his fragility.

Then, to meet Michael Jackson is sharing a little of this suffering in the pain, knowing the man victim of a too blazing success, while undergoing the lynching of those who had adored him.

This pain shows him in storm, trapped, struck by the coolness of an enemy world, sweeping him with the back of the hand, rejecting him with a rare hatred.

Michael Jackson will not go out of it unhurt, victim of this adult world which frightened him... so much victim, again...

J.M. Creation

J.M. Creation

THE GENESIS OF THE STORY

The beginning of a slow agony starts in 1993. At the top of his glory, Michael Jackson changed.

Holder of all the records of sales of LP all over the world since 1984, he knows he had reached the peak of his work.

"Thriller" was the artistic self-fulfillment for which he waited, allowing him to sit a worldwide fame.

"Bad" came to confirm this special status of international star.

The difference between these two LP is in a single song : " Man in the Mirror ", edited in 1988.

Paradoxically, this song is not signed Michael Jackson but Siedah Garrett and Glen Ballard. On a LP containing eleven songs, only the duet with Stevie Wonder, "Just Good Friends" and " Man in the Mirror " are not signed Michael Jackson.

The text of this song describing the click of an awareness for the egoism and indifference to the world will have for ever an indescribable impact on the vision of his career.

During the choice and the recording of this title, the artist perceives an undefinable feeling and this plenitude which invades him while roaring " You got to move ... You got to stand up and lift " will not leave him anymore...

J.M. Creation

If the album "Thriller" demonstrated all the talent of an outstanding artist, moved by a will to break the barriers of the racism and to impose his music to a too "pale" public, "Bad" wants to be more aggressive, breaking the shell of a too courteous and soft star.

To be able to continue his road, the album following "Thriller" had to be its opposite. In perfect warned businessman, Michael knew how to break his image at the right time, changing quite at the same time his look, musical genre and way of singing.

The calculation is completed and the new Michael Jackson catching the crotch makes forget the " victim of the undead ".

In 1988, he wins his bet not to sink into the forgetting generated by too much success.

Between 25 and 30 years, Michael Jackson moved.

He imposed upon the world but he's embarrassed by too much success in a short lapse of time. He ceaselessly has to question and divert his road, not to fall.

Endowed at the same time with a deep intelligence, with a refined analytical sense and with an unusual sensibility, Michael is going to find his plenitude in this " Man in the Mirror ".

He has to prove nothing but the fear of the defeat permanently embraces him. And then, the words of this song return him to the simple human being's rank, the word "star" loses its sense and the man is touched...

To understand Michael Jackson's sensibility, it's above all to study his education.

J.M. Creation

Very close to his mother for a long time because of the disagreement of his parents, he inherited from her sweetness, her patience and her generosity. He also married his religion - Jehovah's Witness - and grew in its very strict rules.

This religion is strewed with prohibitions and taboos. It explains very widely the very reserved, hermetic aspect of the personality of this man.

To succeed, he already has to defy numbers of prohibitions. It's just enough to remember the message by way of introduction of the "Thriller" video where he disputed his support to his own work ! A Jehovah's Witnesses requirement : it's forbidden to evoke the beyond, even less the undead !

Nevertheless, this religion fills the whole Michael Jackson's work : his ceaseless allusions to his faith, his concern to never let appear the slightest photo presenting him under a negative light, his doggedness to propose a clean image for the youth, his will to laud education and respect. He is an example and his image has to be purity and innocence.

The Jehovah's Witnesses watch for the slightest lapse ...

On the other hand, if all these initiatives can be similar to a strategy, the fact remains that Jackson is a very religious man.

God is a part of his life in a real omnipresence and his dreams of success came true in this absolved trust in a supreme Being.

How many times did he evoke the power of dream that becomes reality ? It was only personal experience ...

J.M. Creation

Rocked since the childhood by rules allying severity and generosity, Michael found a diversion from his loneliness in a profound faith.

And for the first time of his life, interpreting furiously " Man in the Mirror " in a recording studio in 1987, he feels provided with a divine mission ... His petitions are prayers; his faith expresses himself without the slightest restraint, bathed in a mesmerizing gospel. The grace touches him...

Since the beginning of the 80s, Michael Jackson took his career in hand. He became emancipated of his father by firing him and manages freely his fate. The blazing success of "Thriller" made of this already wealthy man a fantastically powerful man.

But this anchored faith in him broke any egoism.

Since 1984, he doesn't stop to donate to charitable works, he assures the financing of hospitals, receives sick children, fight against racism and discrimination, advocates the education by financing scholarships students... The world and its sufferings concern him so much that he puts back the completeness of the earnings of his tours to various humanitarian organizations.

And when the song " Man in The Mirror " appears on February 1st, 1988, it's obvious that the profits of its sale are entirely put back in the support against cancer via the Camp Ronald Mc Donald for Good Times ...

Michael Jackson has never made publicity around his humanitarian commitment.

Maybe he didn't want to be the object of political manipulations. But slowly, the idea of the visionary forms in him. What is just habits and

J.M. Creation

normality for him: the fact of holding out the hand to his fellow man has to propagate. It's there only a biblical word…

The most decisive and human bend of his career is outlined on the horizon… There is the mutant !…

J.M. Creation

J.M. Creation

1991 - DANGEROUS

Three years passed since the release of the "Bad" LP.

Sales were considerable and the hits succeeded one another in the charts.

The precarious bend after the extreme success of "Thriller" was perfectly negotiated. Michael Jackson doesn't have to worry anymore about his future. The "Bad Tour " went through the world, he felt a public acquired in his cause, filling colossal stadiums. He can be reassured.

But, " Man in The Mirror " always haunts him ... He publishes his fourth opus " Dangerous " in 1991. The title of this album in itself is already a confession of his doubts ...

"Thriller" was Michael's album, project of his life for which he'd have sacrificed everything.

"Bad" is an indirect answer to the too cute and syrupy image of Michael. The title evokes this bad boy he wants to interpret but without big conviction.

"Dangerous" is a symbolism, directly ensuing from the thought of his creator.

J.M. Creation

Michael Jackson goes into the "dangerous" phase of his career and, regrettably, of his life.

From the 90s, he doesn't stop to put himself in danger.

His humanitarian activism increased. He gives without counting, sacrifices all his earnings and get involved in numerous deficiencies of the system against the child welfare.

Since 1988, he is owner of Neverland Valley Ranch, a 1400 hectare private property, situated in the county of Santa Barbara in California.

This former farm was totally transformed to conceive a gigantic park inspired by Xanadu Palace of Kubilaï's Khan.

This property consists in three wings: the part "house" with swimming pool, tennis, areas of games, surrounded with garden and close to a lake; the part "amusement park" near of Disneyland, and finally, the "zoo".

Acquired for more than 17 million dollars in April, 1988, Michael made it a haven of peace and bliss, not to satisfy his ego but to welcome thick clouds of disadvantaged children.

He shares with some of them a part of a short happiness and even goes as far as creating hospital infrastructures to mitigate any handicap and have the possibility to welcome and accommodate without limitation.

"What inspired me to create Neverland ? It's very simple.

I just shaped the things I had in me. I created things I liked and what I loved the children also loved it, or the child who

J.M. Creation

slumbers in every adult. All the things I was deprived when I was child. Neverland invites each of us to bring out the part of childhood which is in us. It's a place where I think we can be turned to the childhood. You can live there as if you were 10 years old and it's really an extraordinary place. It's immense, we can make quad bike, horse... I like, I'll always like that. I'll never sell Neverland. Neverland, it's me. That represents the completeness of what I am. "

"Bad Tour" ends in January, 1989.

Michael hardly took advantage of his new house but his dream has to come true.

In March, 1989, he invites 200 children of the Institute St Vincent (for handicaped children) in his ranch.

In December, 1989, he invites Ryan White, young AIDS-patient, haemophiliac, excluded from his college, victim of an unacceptable discrimination.

In January, 1990, he invites 82 children, victims of ill-treatment.

In June, 45 others in terminal phase of incurable diseases ...

" Man in The Mirror " haunt Michael.

His life wasn't really happy. His childhood was scoffed, he admits himself victim of ill-treatment. But, he has a revenge to take.

His colossal fortune allows him to give a perfect part. He can help to calm, one moment, the suffering of these children and forget who he is.

J.M. Creation

After all, he sang it with a perfect conviction: " *I saw this man in the mirror, I asked him to change* ".

Then, he acts more and more openly...

"Dangerous" is the outcome of Michael Jackson's dream because he contains a strong text, a "Jacksonian hymn ", an order of reunification : "Heal The World".

" Man in The Mirror " crossed its road in his spirit. The idea to use his exceptional fame to try to modify the mentalities is omnipresent in his life.

He settled this purpose and in spite of the warnings of his advisers who don't stop discouraging him, Michael decided to attack the universal egoism.

The philanthropist side got the upper hand and in man more than ambitious, he doesn't hesitate to dedicate his life and his career to this desperate cause.

But to reach there, he has to go out of the artistic domain and rush into a quasi-political breach. "Dangerous" ...

In November, 1991, the release of the LP is carried by the " Black or White " video.

At first associated with the rumors circulating on his interpreter, as the change of his original color, the sense of this song deserves to be deepened.

Obviously this text is personal. The most hurtful sentence is " *I'm not going to spend my life to be a color* ", thought directly stemming from the spirit of his author.

J.M. Creation

But except this ironic answer to the worldwide trash press, this song is also a hymn against the racism. Michael refers to the equality of races in a country where the freedom is not the same for each. And when he evokes gangs, Nations or Clubs, all the sectarian institutions that still create segregation, his message becomes purely political. Once again, "Dangerous" ...

The logical result of the release of " Dangerous " is the world tour that Michael begins in June, 1992. It's not harmless. Jackson goes through the world, 26 visited countries having welcomed 67 concerts, 9 months of trip. But it's not its gigantic size that makes it exceptional.

Michael Jackson's whole philosophy is in this tour and it gives the real image of "the man in the mirror ".

By occurring in 42 European countries, 16 Asian countries and 11 South American States, gathering an audience about 3,5 million spectators, he can turn his federative side for a noble cause. And this noble cause is his dream : Heal The World Foundation.

Deprived not to be the author of " Man in The Mirror ", he put a lot at every level during the production of this title.

"Heal The World" is HIS hymn and will be forever.

But the Heal The World foundation doesn't directly ensue from this creation. The part "thanks" published in the notebook of the "Dangerous " LP doesn't evoke this project. The LP doesn't serve advertising to the foundation. The idea manifestly germinated later, even if it slumbered in him for a long time. It was thus born and was revealed during the tour, toward the end on 1992, when the title "Heal The World" and its video are promoted in October.

J.M. Creation

Michael Jackson doesn't appear in this video. He shows the world. He is not the actor anymore but the organizer and pushes his public to the awareness.

Always hidden in the shadow, he ordered to put back all the profits from the "Dangerous World Tour" to the foundation Heal The World . Nobody knows anything about it then, but the humanitarian aspect of the star reached its peak.

We know now that approximately 400 million dollars stemming from his personal funds fed the foundation. In his spirit, his own money added to the commitment of his vast public can make miracles.

As always, ambitious, Michael has to deliver his message in the whole planet. His "Dangerous Tour" will not cross the USA, he voluntarily omitted the United States, no man is a prophet in his own country ...

But there is a major, very federative event in the USA, which is the Superbowl, finale of the championship of football. He knows that participating in this event, his audience will be multiplied tenfold.

He signs the contract for this unique and brief representation on the American ground in the only purpose to promote "Heal The World Foundation".

The broadcast of the Superbowl is global, he knows it, and what a better springboard than this event to deliver his message and unite in his cause ?

J.M. Creation

Actually, on January 31st, 1993, 100 000 persons massed in the Rose Bowl of Pasadena attend his allegory on the universal harmony. But especially, near a billion of viewers must be made sensitive in about ten minutes. Michael surrounds himself of about 3500 children and expresses himself briefly :

" Today, the whole world unites in the only purpose to redo the world and to create a paradise of joy and understanding by the willingness. Nobody should suffer, especially our children. This time, we have to succeed. For the children of the world... "

His clothing is sober. The man shows himself ...

This day, Michael Jackson is at the height of his humanitarian activism in a humility that we don't attribute to the stars.

There's in him an unusual mystic will; the artist faded for the benefit of the man. But this man disturbs ...

The progress of this humanist reasoning was strewed with troubles. His advisers, more usual of an icy attitude as for the financial investments, discourage him hardly.

Michael Jackson is an international star, a size of the show business. He detains multiple companies and generates hundreds of jobs.

There's nothing humanitarian in the business. Only lawyers, legal advisors, administrators ...

J.M. Creation

The proof is John Branca's attitude, this lawyer and closed friend, who tempted everything to oppose to the acquisition of Neverland. The artist subjected his dream and collided with the cold vision of a jurist. He had to fight with sourness to impose his choice while John Branca still judged Neverland such a simple financial abyss.

The negotiations were rough, as much with the former owner of the ranch as with his own advisers. How to consider that a fantastically wealthy man cannot enjoy his freedom ?

This example demonstrates perfectly the influence that some administrators of the star tried to practice. And it's not the worst : Michael trusted John Branca for sure; he was the witness of his marriage and his will names him executive in 2002 and is applied to this day.

Aiming at the protection of his interests, his advisors makes the impossible to discourage Jackson of his humanitarian commitment. But this man is not - as some tried to tell it - a stupid artist and an utopian. It's obvious that to make such a career, started at the age of 8, almost under duress parental then under contractual obligations, the small Michael grew very fast, benefiting from a maturity increased by the requirements and the fault of this redoubtable world of the showbiz.

Throughout his life, his choices demonstrate his perfect knowledge of the wheels of this profession. It would be too long to describe here all the manipulations exercised in a single marketing will. But it's evident that this man wasn't only an artist but a real businessman, skilfully applying all the threads that lead to the success.

J.M. Creation

Michael Jackson wasn't an imbecile, no. His career would never have known such a longevity of more than 40 years if such had been the case...

But he's also excessively stubborn. The success of "Thriller" is the direct result of a maniac stubbornness that gives no place to doubt. All the decisions of the star ensue from this relentless stubbornness. After all, he is the boss, he has orders to receive from nobody.

This stiff and very thoughtful personality allows him to impose his choices although he must resist to multiple oppositions.

The " Heal The World Foundation" doesn't arise from an unanimous moment of generosity but from a long and hard arm wrestling between his founder and his advisors. The star win the part but how long ?...

At this beginning of 1993, Michael Jackson is happy.

The images of the Superbowl show an accomplished, proud and hopeful man. He is a leader, a representative of the peace, an ambassador of the universal harmony.

But deep down in his heart, he feels that the perception of his own personality can damage his objectives. And once again, in an initiative maturely thoughtful and prepared, Michael grants to give a very opened interview, so that his character will be better encircled.

And who better than Oprah Winfrey to discuss psychology ?

J.M. Creation

This interview, which is more a portrait of the man, takes place on February 10th, 1993, one month after the Superbowl.

In a merciless logic, it takes place in his ranch, giving access to his universe to those who will take time to listen to him.

Relaxed but very careful of each of his words - his spontaneity sometimes playing on him - the star shows himself very accessible and under a particularly humble day.

For the first time since around ten years, he answers all the rumors concerning him and raises a very light veil on his intimacy.

From this interview only remain the comments on the pigmentation of the skin, his evocation of a disease named vitiligo, the eradication of his eccentricities and his brief explanations justifying the plastic surgery. The confession of ill-treatments undergone in the childhood by an authoritarian and excessive father is added in a smile and by apologizing ...

But, he says it himself, he doesn't want to make cry.

His purpose is not there. In fact, he makes the effort to confide in order to normalize his image and become again what he is for a long time : a simple human being.

With his legendary sweetness, he has to demonstrate that all that he's doing is not actor's play and that he's really expressing his man's sincerity in his commitment.

The press will only retain the stories of oxygen chamber, bleaching of skin and plastic surgery. But his comment was not there !

J.M. Creation

" I like acting for the children and I try to imitate Jesus - I don't say that I'm Jesus!... I try to imitate Jesus, to follow his teaching, by being childish, by loving children, by being also pure as the children, innocent, and see the world with the eyes of an amazed man, with all the magic which that contains. I like that. We receive children, hundreds and hundreds, affected by cancer, and they run, run, enjoy, and knowing that I can make that for them gets me tears of joy. You know, that fills me inside. "

And when we ask him if he's happy :

" what makes me happy ?... Be able to give back what I have, you know, to help people... the Heal The World Foundation I founded, to gather children and heal the world ... We are creating " Heal L.A. " We have three objectives : child welfare, fight against gangs and education in drug ... "

As the artist pronounces these sentences, the " Heal The World Foundation has already financed an operation to Sarajevo. Parcel of medicines, clothes and covers were sent in Yugoslavia.

But since June, 1992, he left millions of dollars in every visited country : in Switzerland, Netherlands, Italy, Estonia, Ireland, England, Spain, Rumania, Japan ...

To financing of orphanages from fighting against the cancer or AIDS, childhood is his major concern.

J.M. Creation

In this year of 1993, the "Heal The World Foundation" very active and present in the world started on hubcaps.

Michael Jackson is apparently proud of it and takes back his Dangerous World Tour while getting involved in every host country, visiting hospitals, orphanages, estimating needs of each and acting consequently.

The image being left by this star today is not only a great performer but a simple and sensitive man, not hesitating to confront himself with the suffering of pediatrics of the planet. Wasn't there a real will not to cut himself of the world and restore a simple human soul ?

The psychology of this character, that even the experts refuse to analyze in a moderate way, is nevertheless summarized in his acts. Michael Jackson isolated at the world only during the lightning success of "Thriller".

How long did he navigate on his "small cloud" and for what did he look to fall again on earth ?

Ambitious man ? Yes, excessively. Conceited man ? Yes, some time. Committed man ? Yes, for a long time, guided by faith ...

Only way of not sliding slowly in the madness was to modify his priorities after an absolute success at the age of 25. Because "Thriller" was in fact the premature outcome of a career.

Success arrived too early in a life... what did it remain, what reason for living ?...

J.M. Creation

In a mixture of frustration, fear, doubt and hope, Michael Jackson had to redraw his life to never sink. His name is too much associated with a " hits machine " or a simple machine. He fights as a maniac to show that he is only a human being but who indeed wants to hear him, except his public ?

Then he shows a frenzy that is in fact only mental health.

All his visits in a hospital environment are the reflection of his permanent need to confront himself with the most terrible suffering to affect him, get acquainted and never lose the mark of his simple humanity. This love that this star distributed with profusion to the children of the world was only the balance of a man, the only means to stick on the reality and never forget humility, mortality.

Michael Jackson was a true humanitarian, roaming in the suffering of his own loneliness...

In May, 1993, the star is invited in Monaco for World Music Awards.

As always, he arrives surrounded with children, rushes into a hotel, a fair girl in his arms.

On May 12th, he receives an award for his disproportionate sales of records.

In the Sporting Club, he's celebrated and worshipped.

A child spent the whole evening sat on his knees... Jordan Chandler ...

J.M. Creation

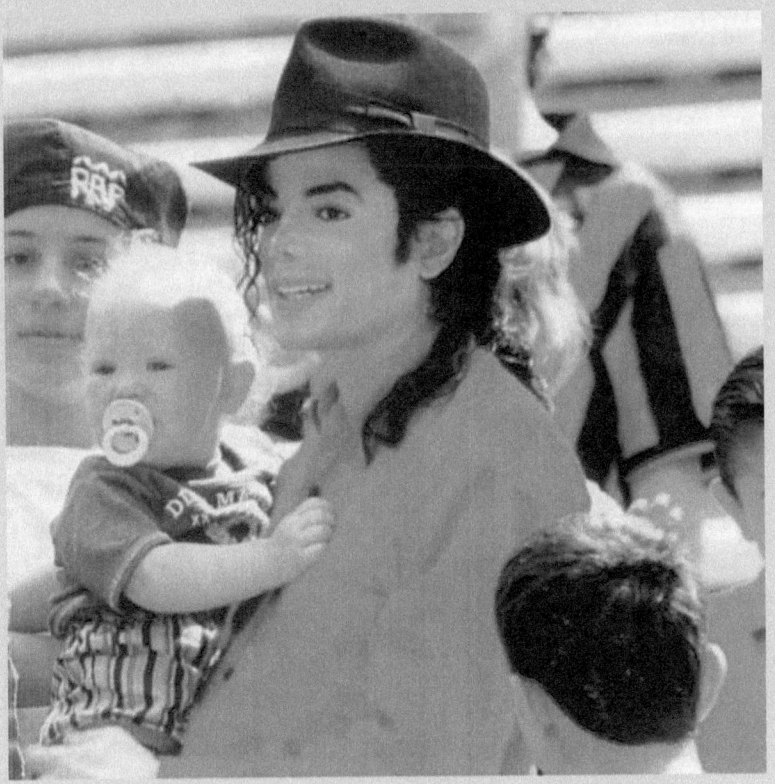

The climbing

J.M. Creation

Who is Jordan Chandler ?

This teenager is not disadvantaged. He is the son of June and Evan Chandler.

The star generally surrounds himself with children from people he knows.

Hating the silence of the suites of hotels during his tours, he mitigates his loneliness by pulling these children for whom he is only a hero and who demand his contact.

And, in voucher "Superman", Michael runs and takes them in his endless and exhausting journeys.

How many children throughout the world frequented Michael Jackson ? Countless...

Jordan Chandler is a Michael Jackson fan for years in spite of his young age. He tried in multiple occasions to contact him and absolutely wants to meet his idol.

He lives with her mother, June, since the separation of his parents.

J.M. Creation

The meeting takes place in the current 91, in vague circumstances, lending a lack of gasoline of a car driven by the star in Los Angeles, without bodyguards, and helped by the mother of Jordan who leads him at her husband's, David Schwartz, owner of a rental agency of vehicles and hurries to present him her son, Jordan.

One thing leading to another, the child bound to the artist.

Invited to Neverland, accompanied with his mother and his half-sister in February, 93, he spends a first weekend with the star.

Then, the invitations multiply : in his apartment of Century City, in Las Vegas, and always accompanied with her mother.

During this stay in Las Vegas, Jordan emits the desire to stay with the artist at night, after having viewed a horror movie. Jackson allows him but, in the morning, is summoned to explain himself to the mother of the teenager.

Evoking his own childhood and his deficiencies, he justifies his attachment to the children and convinces June to trust him - what she makes unconditionally after having questioned Jordan.

The incident is closed and the Chandler family takes advantage of privileged moments, several stays to Neverland, holidays to Disneyworld and various travels.

As much Jordan as her mother are bound to Michael and the time they spend together is going to disturb a lot ...

J.M. Creation

Evan Chandler, the father of Jordan, dentist to Beverly Hills, is a very busy man and a very absent father.

Nevertheless informed about the visits of his ex-wife and his son to the star, he doesn't like this relation.

He contacts at first Dr Klein, dermatologist of the artist, to collect his feeling. Klein presents Michael Jackson as a trusty, heterosexual and very far from being perverse.

Evan Chandler is reassured but nevertheless disturbed. His son is too close to the artist and shows himself indifferent to quite other environment.

Would he be losing his parental authority ?

He contacts David Schwartz, the new husband of June, and asks him to limit the meetings with the singer. But June escapes David, their marriage is questioned since she meets Michael ...

In June, 93, during a visit in his ex-wife for a clarification, Evan Chandler meets Michael Jackson.

Their meeting is not explosive as we could imagine it. On the contrary, Evan Chandler feels the artist in a positive way, estimates him enough man-child but certainly not pedophile.

He even invites him a few days at his home...

Over the moment, the resentment disappears but the father of Jordan is hurt in his pride. He feels that his son escapes him and that in his eyes the paternal figure is now this "famous stranger".

J.M. Creation

He feels dispossessed, asserting that his son is so covered with presents that he became insensible in the attentions of his parents. And June is bewitched ...

At the end of their passage in Monaco, Evan Chandler sees the photos of his son on the front page of the press. This media overexposure displeases him strongly.

He meets again David Schwartz to complain about his negligence to his son, deducing the fact that Jordan doesn't have other social links than the star.

David Schwartz is not agree : Michael brings him formative experiences by his travels in the world.

Both men of June's life begin to be in confrontation ...

From his part, Jackson, irritated by Evan Chandler's constant allusions to possible pedophile tendencies, distanced himself and refuses any contact with him.

In the beginning of July, 1993, Evan Chandler can't stand it anymore. He doesn't bear that his ex-wife and his son abandoned everything to live for and by Michael Jackson.

Besides, this last one has just expressed the wish to invite them to the second part of his world tour, what means months of estrangement ...

He thus crosses the superior speed and engages a lawyer, Barry Rothman, to end the relation between his son and the artist. In the stride, he contacts David Schwartz who - being certainly in very bad terms with June - registers the phone call.

J.M. Creation

This recording is for a long time public.

We hear Evan Chandler complaining about Michael Jackson's silence, describing him such " a harmful man "; he incriminates his ex-wife who doesn't discourage this relation and announces his intentions by introducing the lawyer he has just engaged as being " ***the worst son of a bitch he was able to find*** ", underlining that he's ready to get into debt to prove that June and Jackson make his son suffer.

He ends by specifying that his lawyer will mediatize this story and that his purpose is to remove the guarding of the child to his ex-wife. As for Jackson: " ***it will be worse than his worst nightmares, he will not sell a single record anymore***", his career will be destroyed forever.

Evan Chandler:

" This man is going to be humiliated beyond belief, he will not believe what is going to happen to him beyond his worst nightmares. Record He will not sell one more. Yew I through with this go I win big time. I will get everything I want. They will be destroyed forever. "

David Schwartz is embarrassed. He warns June and subjects him the recording.

Panicked, she contacts her lawyer, Michael Freeman, then decides to evoke the situation with Michael Jackson.

He acquaints with the recording and turns to his own lawyer, Bert Fields.

J.M. Creation

At the same time, he appeals the services of a detective, Anthony Pellicano.

Pellicano starts his investigation by questioning June and Jordan, in private, on July 10th.

Jordan Chandler denies the existence of abuse.

The negotiations between lawyers are centered on the fact that Evan Chandler suffers from the absence of his son. They conclude an arrangement so that Jordan spends a complete week with his father.

But June makes a terrible error : at the agreed moment, she refuses to present her son to Evan and decides to take refuge in Neverland to celebrate her daughter's birthday.

Michael Jackson contacts his lawyers when he understands that June will not run in spite of the preliminary agreement. He anticipates the danger and asks the mother of the teenager to respect his commitments while reminding her that he is nothing and especially not the father of Jordan...

June turns around against the star and gives up her stay to Neverland.

From this moment, the situation doesn't stop irreparably deteriorating ... Henceforth aimed against the singer, June resumed contact with her ex-husband, Evan Chandler.

J.M. Creation

She confides him her son during some time and signs an official document drafted by Evan's lawyer, making a commitment not to take the child outside Los Angeles.

Informed about this agreement, Michael Jackson's lawyer contacts his customer, wondering about the real intentions of the mother, orders him not to accept the slightest contact with no member of the Chandler family.

When Evan Chandler asks to meet again the artist, his request is refused. Michael Jackson considers himself already betrayed by all these people...

But to keep a distance and break any contact is not sufficient. The Chandler case is slowly set up in hallucinating steps that even the jurists of Jackson hadn't anticipated.

In mid-July on 1993, the lawyer of Chandler contacts a child psychiatrist, Mathis Abrams, a judicial expert, to make a psychological expertise of the teenager.

Only basing himself on the statements of the lawyer and without ever having met Jordan, he establishes a report that we can qualify as "kindness ", swamping Michael Jackson, describing him such a perverse individual endowed with an inappropriate behavior and strongly suspecting the existence of sexual abuses.

From his part, the father of Jordan wants to be active.

At the beginning of August, he proceeds to a dental extraction on his son and doesn't hesitate to inject him a substance named Amytal Sodium, classified as psycholeptic and hypnotic, but especially used

J.M. Creation

in the judicial domain as "serum of the truth ". Strange relation from a father to his son if this version of facts is real ...

However, at this precise moment, Jordan Chandler suddenly remembers having undergone sexual touches emanating from Michael Jackson ... The Chandler case exists under the cover of a totally falsified psychiatric expertise and an improvised chemical hypnosis session... The rumor will make the rest...

Conscious of the potential danger of such a scandal, all the protagonists of this dirty affair agree to meet on August 4th, 1993.

Michael Jackson and his detective, Anthony Pellicano, meet around a table of negotiations, in front of Evan Chandler and his son Jordan. Before any discussion, Jordan runs towards Michael Jackson and throws himself into his arms ...

But as soon as the debate begins, the star understands the charges of his father. Bewildered, he reads the report signed by Mathis Abrams, the child psychiatrist.

Nobody still evokes the confessions of Jordan at the time of this negotiation.

On the other hand, his father bottom in tears as if he was himself the victim...

The jurists of the artist conclude that Jordan Chandler is not in the center of this case towards the star but the stake in his parents,

J.M. Creation

quarrelling his guarding. The atmosphere has a smell of sulfur and this family is as hostile for the singer as for the teenager.

 A few days after this meeting which was only threats for the artist, Evan Chandler contacts Anthony Pellicano and proposes an arrangement for 20 million dollars, still threatening with legal proceedings and swearing to make his son testify.

 His proposition is subjected to Jackson : hurt in the depths of his being but always worried of fighting up to the end, he declines his offer and insists on the fact that he'll never conclude any agreement of this kind, and rather accept legal proceedings.

 But Anthony Pellicano feels the danger and incites the star to negotiate an agreement to avoid a loud scandal.

His jurists finalize what will be his unique proposition : because Evan Chandler likes the cinema and is a scriptwriter in his spare time (he's the co-writer of *Robin Hood, Men in Tights* - Mel Brooks), a contract offering the writing of 3 scripts over 3 years for a 350 000-dollar amount each is subjected to him.

But Evan Chandler sweeps this proposition with the back of the hand : he agrees to create 3 scripts but for 5 million dollars each !

Jackson ripostes last time: a single script, 350 000 dollars !

The case is about to burst in this ultimate arm wrestling...

J.M. Creation

On August 17th, 1993, Evan Chandler, mad with rage, loses patience. He drives Jordan at Mathis Abrams, the expert having drafted the amazing report against Jackson without ever having met his pseudo-victim. At the same time, he has to answer a summons of the court seized to define the definitive guarding of Jordan.

The teenager lives with her mother and June wishes to keep his son with her. Evan doesn't want it, claiming that return the teenager to his mother will send him back to Michael Jackson's " claws ".

But at the conclusion of this audience, Evan Chandler lost the guarding of his son and has to return him to his mother that day, late in the afternoon.

Meanwhile, by the biggest of the fates, Jordan confided to the child psychiatrist and finally confessed to have undergone sexual touches.

The order of things is upset. Jordan doesn't return to his mother. The doctor contacted the authorities and the teenager is questioned first by social services then by police.

"During the nights spent with Michael Jackson, their intimacy would have modified as time goes by and during their stay in Monaco, the star would have exceeded the cape of touches."

From the next day, August 18th, the artist is informed about this reversal.

According to his close relations, he would have collapsed while commenting : " it's my word against Evan's and he is so, so jealous... "

J.M. Creation

At the same moment, June and David Schwartz are questioned by the police.

Their testimonies indicate that they've never judged the star hostile to Jordan and that the teenager is manifestly manipulated by his father with the aim of obtaining the guarding.

And actually, at this precise moment, he wins : social services remove the guarding to his mother the time of the procedure.

On August 20th, 1993, Michael Jackson has to leave the USA to pursue his "Dangerous Tour", the next stopover is the Thailand.

On August 21st, after his departure, the justice grants a search warrant to search at the same time his Neverland Ranch and his apartment of Century City. Both places literally returned by the police, after having photographed and measured every room, seizes books, videos, photos, administrative documents as well as Michael Jackson's intimate diary (nobody knew it; he just wrote his reflections on his family and his faith).

However, these searches took place in discretion and nobody is still informed about the proportions that this case is setting.

But in a few days, the tongues free and finally the journalists hurl themselves on the information and make THE bloody scoop.

Anthony Pellicano rushes in the front cameras to take the defense of Jackson but makes an inconceivable mistake : while the media don't know the motives of the searches, he exonerates the star of all charges of sexual abuses ! Some delight in this even today !...

J.M. Creation

Since the Thailand, Jackson cries his innocence out and declares to expect the " *rigor and impartiality of the police* " to this investigation to the truth.

At the same time, June and David Schwartz wonder about the future.

If the Evan Chandler thesis turns out justified in front of a court, the mother will definitively lose the guarding of her son for negligence, what she won't bear.

In a new unexpected reversal, they join the father of Jordan and pursue the singer in spite of their initial testimonies, totally acquitting the singer !

Taken in this unbearable storm, Michael Jackson suffocates.

Manifestly affected, he cancels two concerts in Thailand, on August 25th and 26th, 1993, pleading troubles of dehydration.

But he sets on him and goes back on stage on August 27th.

At the same time, his American team operates everything to protect his image.

Children having regularly frequented him are presented to the public via some television channels. They tell their nights of friendship spent with Jackson.

But this defense turns out ineffective; the public becomes alarmed : What ? Children in his bed ?...

J.M. Creation

Some members of his family rush in Thailand.

Liz Taylor joins him for his birthday, on August 29th, in Singapore. She finds an unrecognizable Michael Jackson, having taken refuge with medicines : antidepressants, painkillers.

Jackson flies. He wants to hear nothing more and even refuses to assure his defense.

Liz Taylor doesn't leave him anymore, participates in his defense by chairing the meetings and takes care of the management of his whole life. She attends his slow descent into hell, supporting him without ever weakening, being afraid that he commits the irreparable.

Weeks pass, days follow spreading their lot of rumors according to the humors of the writers of tabloids. The image of the star is made dirty and Jackson pursues his tour in the world with difficulty.

His defense dominated by an attempt of extortion collides with the resolute prejudice of the media.

In some weeks, he's not anymore a musical genius but an animal, pursued by those who lynch him. And this pressure brings him down ...

August 30th, his concert of Singapore is cancelled a few minutes away from its start. Michael Jackson fainted and must be transferred to the hospital.

He goes back on stage the next day ...

J.M. Creation

At the same time, a U.S. TV channel broadcast the phone recording in which Evan Chandler announces his only will to destroy the star.

But the machine is launched and nothing stops the rumour, not even this very significant document, that demonstrates the doggedness of a man ...

In September, Jackson pursues his exhausting trip in this "dangerous" atmosphere. Taiwan, Japan ...

On September 10th, 1993, we learn that Gloria Allred, famous lawyer specialized in the defense of civil rights and representative of Jordan Chandler gives up the defense of her customer. Having previously declared that she took care of the file of this "brave child " who deserved " to be protected ", she makes suddenly off without giving a slightest explanation.

"Dangerous World Tour" - who has never carried as well its name – continues : Russia, Israel ...

There, he learns that the American justice gives a month to decide on legal proceedings. The criminal investigation takes its course but decision will be ruled in October.

Turkey, Spain, Argentina, Brazil, Chile, Mexico... he runs out ... Every representation on stage becomes a Calvary.

J.M. Creation

Just a perspective in front of him: stress. Stress of the tour, stress of movements, stress of isolation, stress of threat, stress of a possible trial, stress of prison ...

His life becomes a hell and his consequent losses of weight that he undergoes after every concert still aggravate his health.

His fear prevents him from feeding normally when it's crucial to maintain the balance. His health languishes every day a little more but he can't stop contractual obligations. He finds no more rest. The bottom of the abyss is not very far...

On November 13th, 1993, out of breath, he announces the premature end of his tour.

He clearly evokes his dependence in drugs and necessity of being quickly look after.

" I'm conscious that it's impossible to me to assure the continuation of my tour and I'm regrettably obliged to cancel the remaining concerts. I know that I can surmount this pain and that I'll go out more hardly of this experience.

While I began my tour, I was accused of horrible acts. I was profoundly hurt. I feel an immense pain at the bottom of my heart. These deceitful assertions, added to the efforts of a tour, physically and psychologically exhausted me. I began to take always more painkillers to hold out ", he declares via an audio recording.

He announces to begin a detoxification and disappears.

J.M. Creation

We'll talk again in 2009 about this habituation in drugs.

A lot of his fans - too protective - persist in denying the evidence of this dependence today.

Nevertheless, this period 1993 is manifestly the release mechanism of this poisoning.

In this unique declaration of November 93, Michael Jackson clearly confides his use to drugs. He quotes painkillers but a simple analysis of the facts demonstrates a too "dangerous" situation not to affect his psychological balance.

Painkillers were quickly associated to this unfortunate accident arisen in 1984 during the shooting of a Pepsi publicity.

The premature explosion of a smoke had fired his hair and caused consequent burns.

Not having noticed its nearness, he'd tumbled down a staircase without batting an eyelid while the fire already ravaged his hair. Reached at feet of the staircase the help had intervened. He got out of it with burns in second and third degree of the scalp and had to undergo multiple transplants of skin to reconstitute the damaged zone.

1984 symbolizes the entrance of painkillers in Michael Jackson's life for independent reasons from his will.

1993 cannot definitively be the only reflection of pains provoked by this accident arisen nine years earlier ...

J.M. Creation

The facts demonstrate that he met the Chandler family in 1991. They also show that their relation began to degrade in the year 1992 when the assertions of pedophilia were blown on multiple occasions by the father of Jordan. The case lasts for almost one year and the sword of Damocles threatens him seriously.

All those who know well Michael Jackson and follow his career for several years perceived the personality of this man. He has nothing of a Titan.

And even if he seems armored by a very premature attendance of this hard middle of the show business, he has in fact a slender shell to protect himself.

This artist is ambitious : accustomed to swipe trophies and collect records; too much perfectionist to content himself with the mediocrity.

His psychology is evident : he's flying. Conditioned since his youngest age, he aims only at the success. And these assertions upset his career plan.

In his biography " Moonwalk ", he confides to have very badly lived the physical changes of the adolescence. "Raised" by his "father-manager" to be a "success machine ", the fear embraces him when his future is questioned by his growth. He refrained himself from the defeat. He will not disappoint his father !

Then, these people who cross the " small Michael " and don't recognize anymore this exceptionally gifted, mesmerizing kid, deeply perturb him. This teenager not in his shoes will engender a furious man, mad of ambition, determined to succeed at all costs, whatever the pitfalls.

J.M. Creation

The Chandler case threatens his career in a radical way.

For the first time of his life, he collides with the failure. He can make nothing, or only give in to the blackmail and pay !

This configuration is not familiar to him even if he's used to the threats, to the blackmails, to the trials for everything and anything. How many individuals by year pursue him in front of Courts ?

For claimed plagiarisms, for recognitions in paternity, for excessive breaks of contracts ? He knows well the justice to regularly frequent it. He's permanently surrounded with jurists and notes every procedure. But there, they lend him touches on a child !

A crime liable to years of prison !

A consequent part of Michael Jackson's psychology explains just because he's Jehovah's Witness.

A whole book could be dedicated to this ascendancy of the religion for his youngest years.

He is the direct result of the rules of the Jehovah's Witnesses and this profound faith leads him for a long time.

It's obvious throughout his life he leaned on these teachings in each of his decisions. This faith anchored in him guides his life and brings him a matchless comfort for years. And this unchanging faith justifies his innocence in these nauseous cases...

J.M. Creation

He, who always strove to help his fellow man; he, who always wants to distribute a part of his luck; he, who set up a kingdom dedicated to the childhood to welcome the most unlucky, is accused of the most obnoxious, the most perverse crime !

How to manage these assertions which go against his faith, against his ideology, against his personality ?

How to accept these degrading suspicions ? How to counter this terrifying evil ?

The Chandler case had indescribable consequences on Michael Jackson's psychology. And it's certainly not simple analgesic that were able to relieve his suffering.

It's obvious that he knew a real nervous breakdown and that, maybe even, the idea of suicide touched him.

When we notice that he made five months of tour in 1992 for 45 concerts and 3 months in 1993 for 24 shows by going through 26 different countries, we can assert in almost sure source that he gave in to the temptation of medicinal excess to take drugs at first and try to get back to suppress fear, to try to find the forgetting in the middle of the excitement.

But, " Man in the Mirror ", it is him ! He can't have committed such ignominies while he spread the biblical word by lauding the love of

J.M. Creation

his fellow man ! And what he feels as the most terrible injustice destroys him slowly...

Then, in this November 93, when he announces the forced abandonment by the last dates of his tour, it's obvious that Michael Jackson is under the influence of drugs more dangerous than simple painkillers.

The exhaustion provoked by the stage, the dehydration, the appetite cut by fear, the hopeless lose of weight, the stomach filled with diverse and varied pills, are right of him. Because after all, although too much people thought it, he isn't a machine but a simple human being ...

He has no more choice and has to give up even if the idea to give the victory to Evan Chandler gives him nausea. If he assumes the calendar of his "Dangerous Tour", he will put his life in danger.

And even if his circle strives to protect him from obnoxious charge declarations, even if his jurists try to hide him the terms of the complaint of Chandler, he knows that the words masturbation and fellatio were pronounced. Nothing will relieve this pain of a crime condemned by God!

He sinks in depression, doesn't dominate anymore his fear ...

The weeks that follow are similar to a real world manhunt that will push even more his reputation.

Media looks for him on the whole planet; would he be trying to escape the American justice ?...

J.M. Creation

His lawyers announce a forced isolation from six to eight weeks when "wanted" are launched by the press !

Would he be in Switzerland, in France, in England ? Rewards are even offered to the possible advisers to localize the star.

Liz Taylor is also tracked ... An absolute frenzy ...

The answer of this disappearance was nevertheless simple when we know the character.

Of course, his lawyers didn't lie. Of course, he had to undergo a hospitalization and a lasting isolation. It corresponded not only in a detoxification but a thorough treatment of his nervous state. Nobody is marble in this world and Michael Jackson had never hidden his fragility...

Only the medical secret could bring him the comfort of the anonymity. And if, so many years after these events, we suppose without certainty that he benefited from care in an English private hospital, it's that only the medical secret really protected him from attacks of the world. Sinister report ...

But "fortunately", in this hum, a small voice rises and starts a real hurricane:

J.M. Creation

" It's very difficult for me. Michael is my brother, I like him very much but I can't, I don't want to be in collusion with his crimes against innocent children. If I keep silent, I'm also guilty and humbled that these children. I saw checks in the order of the parents of these children. I don't know if Michael buys these children but I saw checks. It's my mother who showed them to me, they are very big sums, really a lot of money.

It's the first time I speak about it. I didn't want to speak about it but it's too sad. I'm myself a victim then I know what that makes. These children are marked for life, I don't want that other children suffer in this way. I like Michael very much but I worry about these children, because their life is wasted, really. "

- La Toya Jackson - December, 1993.

Since the middle of November, the charges fuse from everywhere. Former five bodyguards lodge a complaint for unfair dismissal, claiming to have witnessed his perversity.

The statements without suites - but paid interviews - of former drivers, former employees of Neverland come to be added ...

The statement of La Toya is an unstoppable deathblow that opens for ever the doubt on the morality of the star; her comments are too much accusatory.

J.M. Creation

The whole Jackson clan raises against her :

" She's crazy. She's a liar and I shall say it to her eye to eye. She lies and she knows it. "

- Katherine Jackson

" You should not believe what she says, it's totally false. My brother is not a pedophile. For these people, it's just a means to make money. I'm very angry. That has to stop. For La Toya, it's just a means to advertise. "

- Jermaine Jackson

" She lies all the time. She earns her life with lies. Everybody knows La Toya, everybody knows what she's able to do. She's manipulated by her husband. "

- Joe Jackson

Michael Jackson will never reveal his feelings about his sister, La Toya.

He will keep his disappointment in the depths of himself and will never express himself on this subject.

But it's obvious that this explosive statement makes considerable damages. And although the press and media assimilated her to a real

J.M. Creation

Judas without lingering too much over her comments, La Toya Jackson - who will apologize some time later for having been victim of an excessive husband, having forced her to lie - generated this day a real evil.

What to say about the attitude of La Toya ?

How was she able to join the clan of the adversity against her own brother ?

In this time, La Toya made spoken a lot about her. Certainly deprived to not meet the success, she evolved between photos of charm, musical productions with no future and charges of ill-treatment.

For the same period, Janet Jackson, began to made a "first name" in the showbiz, since the ringing success of "Rhythm Nation".
Very fast, Janet became the second ambassadress of the Jackson family, pointed as deserving successor of her older brother.

La Toya Jackson didn't bear not to reach the same fame, to the rank of these too talented persons...

She's only known for her boldness, her provocation and her sulphurous declarations and messages.

Artistically, she collides with the absolute vacuum...

In 1993, when she frankly accuses her brother of pedophile acts, she just edited a few months earlier a book about the Jackson family, in which she accuses her father of incest.

In two words, she was raped and, in the stride, she involves Janet, also indicating her victim of this incestuous behavior.

J.M. Creation

No member of the family will express himself on this biography. But really nobody and never !

At the release of this book in which she grazes everybody, without exception, La Toya became pariah of the family.

The photos of charm had displeased. The biography was too much !

When she appears in front of cameras to push her brother and directly accuse him of a crime liable to 30 years of prison, we can really wonder about her mental health.

But for the family, she has just touched the bottom ! She will enter from then on a long time in the wilderness, isolated of her family and mistreated by a violent husband.

As for Michael no one knows what he thought about her. But it's not difficult to imagine what he felt...

Last point to be noted, and not the slightest: La Toya uttered this day an assertion. We can wonder why Los Angeles Police Department didn't proceed to an official interrogation within the framework of investigation opened against Michael Jackson ...
The story notes that La Toya Jackson supplied a testimony in front of microphones and not in front of policemen... weird...

J.M. Creation

At the end of November, 93, the Californian justice announces the date of the civil trial on March 21st, 1994 and evokes the eventuality of a penal trial.

Jackson is summoned to return in the United States to make his testimony under the threat of an international warrant for arrest.

Jurists' team that built the defense of the artist is confronted with divisions.

Anthony Pellicano resigns under the criticism of a too aggressive and ineffective defense.

Bert Fields, lawyer since the beginning of the case, also makes off further to a deposited motion to obtain the adjournment of the trial against the wishes of Michael Jackson.
John Branca is re-entered in the team, beside Johnnie Cochran.

Their unconfessed task is to end in an arrangement, being persuaded that the singer will never psychologically bear such a trial...

At the same time, the American justice pursues its investigation to estimate the legal proceedings.

Auditioned by the Grand Jury, Jordan Chandler asserted having seen Michael Jackson naked on multiple occasions and made a detailed description of the tasks of depigmentation in his body.

He heavily insisted on his genitals.

J.M. Creation

The Grand Jury wants to be sure of the truthfulness of his assertions.

He drafts a warrant authorizing the examination and the photography of the body of the star. Michael Jackson is not obliged to accept it but the court underlines that a refusal would be confession of guilt.

On December 20th, 1993, Jackson submits himself to this warrant.

The examination takes place in his ranch in the presence of the representatives of the charge : Thomas Sneddon, district attorney accompanied with a detective; Gary Spiegel, appointed photographer; and a doctor.

The singer surrounds himself with his own witnesses for the defense: his personal doctor, David Forecast; his bodyguard and old friend, Bill Bray; his two lawyers and his own photographer.

His lawyers and Thomas Sneddon decide to leave the room.

Jackson requires that the detective come with the district attorney also made.

In an extreme emotional state, he rises on a stage in the middle of the room and begins to undress totally.

The examination lasts approximately 25 minutes in the course of which he is bombarded with flashes without ever being touched.

J.M. Creation

This day, he undergoes the humiliation of multiple pictures and videos of his nudity and feels laminated.

To express these facts without trying to imagine their reality is harmless.

For too numerous years, the impasse is made on the dirtiest episode of this case - and certainly unique in judicial subject.

Nevertheless, it's necessary to stop on this compulsory examination and try to understand its contents.

Michael Jackson is a shy man. It's not an actor's play, his body language frequently betrays this reserve.

To make it "group of Motown", Berry Gordy didn't skimp on the means. The education of the five boys was assured and they were even entitled to lessons in deportment.

For a long time, Michael knows extreme politeness and savoir-vivre. But, by observing him in public, we notice that some of his steepness are more uneasy feeling. Hands in the back so they don't get lost in pockets; hand in front of the mouth to hide a smile, and even these surgical masks, this will to totally hide him, give evidence of a shy man who looks for intimacy although being public.

This shyness joins to a real malaise and an absolute deny of his own image.

Michael Jackson doesn't like himself and suffered from his physical appearance almost all his life. No need to evoke here the plastic surgery.

J.M. Creation

Diving back into his adolescence, he already fell back simply because of his acne. Afterward, in the 80s, he had to manage the appearance of the vitiligo.

And what a drama for this man !...

We can easily imagine the very destabilizing aspect of this disease. On a black skin, only the white haloes are obvious.

And how to shade off this peculiarity ?

We can't be blind : on a black area, only the white is striking. Michael had to manage to use creams of bleaching to unify his skin tone. But he was a public character ...

Over the years and with the aggravation of his disease, he reached an extreme paleness that made flow so much "black ink " !

The jokes multiplied and Michael slowly became the privileged target of the humorists.

But did we suspect what there was behind this strange disease ?

The man lived very badly this test imposed by the fate. He avoided stolen photos so that we don't distinguish this imperfection.

He tried to dike the disease by consulting a multitude of doctors, unsuccessfully...

He'd suffered of simple acne in his adolescence, how did he live the vitiligo?

J.M. Creation

Maybe to understand it's enough to imagine the days of adversity we all knew, when a big spot in the middle of the face ruins our days and so profoundly affects our self-confidence.

Who didn't know such a moment of deep malaise in a society where air is so essential ?

Subject to the vitiligo, Michael Jackson felt the same sensation every day of his existence, with an furious envy of returning at home and hiding from the world.

He surmounted this handicap only for his passion : music, dance, art.

A lot of photographers and directors often complained about the violent light he required to overexpose his skin.

Did they understand that it was the only means of erasing the tracks of the vitiligo he refused ?...

How his lawyers convinced him to accept the examination ordered by the justice ?

Replaced in its context, this episode intervenes five weeks after the interruption of his world tour. He also shortened his isolation - and certainly his care - to return in the USA and submit himself to the Californian justice that already brandished an international warrant for arrest.

He's just put the foot on his native ground, he's already expected for this " special session ", that we really can't imagine.

The word humiliation is maybe weak for a man, suspected without a slightest proof, who has to remove his pants to prove his innocence!

J.M. Creation

Worldwide Justice archives find no similar case, of a supposed pedophile, having had to show his penis by way of irrefutable proof !

This day, under the unchaste flashes of a justice that lost the reason, Michael Jackson underwent a unique treatment, that leave indelible tracks.

Thomas Sneddon – district attorney of Santa Barbara - still laughs at it ... Evan Chandler had already won...

Nevertheless, if the singer bent in front of this dirty examination, no doubt that he gave evidence of his innocence.

Afterward, we can wonder about his obedience when it would have been enough to pay, so that this nightmare ends.

Some today remember this case only its conclusion by an arrangement without stopping a single moment on the tests imposed before its term. He is the only one presumed guilty of the world to have laid bare in front of the courts - and it's not a simple expression ...

It's easy to close eyes and imagine the torture, the infringement on the dignity, the devastation of the pride.

This examination was similar to a rape under the cover of the search for the truth. Its intention wasn't fair, not protecting at all a teenager of a dangerous pervert but just humiliating one of the biggest American entertainers, for the pleasure.

J.M. Creation

There was behind this warrant a profound hatred, a primary racism, a will to destroy. There was nothing else than an aggression, protected by the flag of the United States.

There remains from this decision a report with the description of a "Dalmatian", photos and videos under seals today.

What was the real vocation of this special examination if it was not the humiliation, the dominion and the subjection ?

What brought these claimed pieces of evidence if it's not a constant threat for the examined person ? The fear that these pictures are revealed, the fear to see his intimacy exposed in media, web...

From his part, Thomas Sneddon already prepared his file in a penal trial against Jackson. He already satisfied to amaze the members of the jury by producing the results of this meticulous examination. He already savored his effect by imagining the comparative degree between the description of the accuser and these pictures...

Nevertheless, the report generated by this examination concludes in **not really convincing resemblances** with the description of Jordan and mentions a handsome incoherence : the teenager evoked the **circumcision** of the star, **which is not**.

It doesn't matter, Sneddon exults... Michael trembles... he's finished ...

J.M. Creation

But going out of this nightmare, he doesn't lower arms and continues to proclaim his innocence.

Profoundly bruised but always vindictive, he's anxious to express himself on December 22nd on CNN to reveal to the world the cynical treatment he has just undergone.

The destroyed face, trembling voice, with tears in the eyes, apparently affected, he declares :

" **Numerous assertions were carried against me. These assertions are totally false. As I say it since the beginning, I hope for a fast outcome in this terrible nightmare.**

I'll not answer the charges here, my lawyers having told me that it's not the place.

I'm upset to see what spread the merciless media. They systematically dissected and distorted every rumor to draw their own conclusions. I ask you to wait to know the truth before condemning me. Don't treat me as a criminal because I am innocent.

I had to submit myself to an inhuman and humiliating examination ordered by the sheriff of Santa Barbara and the police of Los Angeles. Their warrant authorized them to examine me and take photos of my penis, my buttocks, my low stomach, my thighs and quite other part of my body. They looked for tracks of depigmentation, tracks of blood or quite other skin disease, as the vitiligo I have already spoken.

J.M. Creation

According to the warrant, I had to cooperate with the doctors in charge of examining me and defining the state of my skin to know if I suffer a disease.

I was informed about the fact that I couldn't refuse this examination. If I refused to cooperate, this refusal would be mentioned in the trial, establishing my guilt.

I lived the most humiliating moments of my life. Nobody should ever undergo that. Having undergone this despicable examination, the parties in presence were not still satisfied and took other pictures.

It was a nightmare. A terrible nightmare. But if it's the price to be paid to prove my innocence, my absolute innocence, then I accept.

I dedicated my life to help thousands of children. I have tears in the eyes when I see a child suffering. I'm not guilty of the facts they blamed me. The only thing of which I'm guilty, it's to give all that I have to the children of the world, it's to love them whatever their age or race, it's to like the cheerful and innocent face, it's to live through them the childhood I didn't have. If I'm guilty, it's to follow God's words: " let come to me the children because the heaven kingdom belongs to them. "

I don't take myself for God, I just try to be at his image in my heart.

J.M. Creation

I'm guilty of no offence. I know that we'll prove all this is false.

You, my friends, my fans, I thank you from the bottom of my heart for your support. Together, we'll see the end of this test. I love you. God bless you all. "

At this end of December, 1993, after four months of scandal, Michael Jackson is at the height of physical and psychological exhaustion, as shows it the video of this statement.

After a "dangerous" habituation in medicines, after a "dangerous" isolation to treat his depression and at the conclusion of a "dangerous" unchaste examination, nothing alters his pugnacity and his desire to prove the truth of his innocence.

He remains a definite man, stubborn as usual, ready to sacrifice everything to be washed by any suspicion. But what is going to follow doesn't stick on this image, and for cause …

J.M. Creation

In January, 1994, the first rumors of an arrangement begin to circulate. They are quickly confirmed at the end of month by the lawyer of Chandler : Michael Jackson accepted a financial compromise in exchange for the retreat of the complaint.

The civil trial planned in March will not take place.

Media burst out again against the star : *"If he paid, he is guilty* ! " The speculations make good progress on the amount of this agreement : 10, 20, 30, 50, 60 million dollars... what is the price of the silence ?...

The defense of the artist tries to answer this new lynching : nothing will prevent the accuser from testifying if the justice starts legal proceedings, continuation that is not decided yet.

This compensation was in fact to the amount of 10 million dollars deposited on a blocked account until the majority of Jordan Chandler, paid in 5 years; 1 million dollars in each of both parents and 3 million dollars in the lawyer, Larry Feldman.

J.M. Creation

Johnnie Cochran, lawyer of Jackson, contents himself with a laconic statement :

"he is an innocent man who refuses that his career and his life are broken by rumors and insinuations. "

In the end of April 1994, the Grand Jury of the county of Santa Barbara concludes in a dismissal of the charges in the Jackson case. The Grand Jury of Los Angeles did so in September 94.

There are no legal proceedings, the Grand Jury being obliged to classify the file, having questioned hundred of witnesses among which about forty children having very regularly met the singer.

The court comes to the conclusion that they hold no witness who confirms the facts advanced by Jordan Chandler; they have no material evidence or visual witness; they consider the particular family context of the protagonists of the complaint, they are obliged to give up any legal proceedings against Michael Jackson.

We are there in this first half of the year 1994... But what happened ?...

A lead silence comes down suddenly on the Jackson family and nevertheless, there was so much to say ...

J.M. Creation

Yes, there were so many motives to explain this arrangement ...

And the first one - and not the slightest - carried Thomas Sneddon's name ...

If the meeting with the Chandler family was a curse for Michael Jackson, the entrance to Thomas Sneddon in his life is the end of his serenity.

Thomas Sneddon is the District Attorney (prosecutor) of the county of Santa Barbara.

He is known to be an uncompromising and obtuse person, exercising his role with an iron hand.

He is a man of conviction, he pleads the justice and follows only his intuition to lead his cases.

In brief, he is unrelenting as soon as convinced that the crime roams ...

Woe to Jackson to have crossed the path of this magistrate ...

Thomas Sneddon doesn't like this pop-star who pollutes media for years; this black became white, showing a strange image of the American citizen in the world.

J.M. Creation

He's convinced of his guilt from the beginning. It's obvious, these "people" consider themselves over the laws by the power of money.

For him, Jackson has the profile-type of the pedophile, playing on an angelic image to hypnotize his victims, buying the silence of the adults by covering them with luxurious presents to blind them better. Yes, this guy, or rather this "thing", can only be perverse.

Neverland speaks about itself : it's only decoy, claimed kingdom dedicated to the childhood changed into pedophile's mark. Everything is evident !

As soon as Sneddon has the Chandler vs Jackson case, the singer is already condemned ...

Surrounded with his lawyers and advisors, Jackson is informed about his real opponent. No, it's not Evan Chandler. No, it's not the civil trial that threatens him but indeed the instruction opened by the county of Santa Barbara – his place of residence - and led by Thomas Sneddon.

The district attorney will not save him, as far as he has behind him a lot of residents of this peaceful county who would like to get rid of this noisy star !

From the beginning of the case, Thomas Sneddon got involved with an evident partiality. He doesn't search for the truth, he wants to pin Jackson, to nail him in the pillory.

J.M. Creation

If Evan Chandler had betrayed himself during a phone call by admitting that he wanted to destroy the star, no need to hear his voice to feel Thomas Sneddon's hatred...

 The jurists who work on the defense of the singer know well that they have an enormous problem. This district attorney has his reputation. He is pugnacious, propped up and moves back in front of nothing.

Numerous complaints were deposited against him for unfair procedure, plot and violation of the civil rights. Thomas Sneddon is a real nuisance in this case and it's not as easy to fight against him than against a simple citizen. He's a terrible enemy who uses the Law to justify his attitudes.

 The defense of Jackson is very shy by his presence. And he shows obsessional signs very quickly.

 If Gil Garcetti, district attorney of Los Angeles, leads the investigation with level-headedness, he's pushed aside by Thomas Sneddon, who displays all his skill to strengthen the measures against the singer.

 And then, he speaks a lot... He discusses the Jackson case with the press, he assures to have proofs of assertions... In brief, without being judged, the artist is already guilty...

J.M. Creation

The more the time passes, the more the defense worries.

If the investigation started in a usual way by the audition of witnesses and the searches of the multiple residences of the singer, it quickly took looks of vendetta.

The auditions multiply in weeks. In the end, more than two hundred witnesses are questioned, from the most credible to the silliest, without distinction.

And then the climbing intervenes and there, the defense is in total perdition, not finding arms to protect their customer...

The climbing is this strange "examination" that Michael Jackson has just undergone. Thomas Sneddon imposed him and they were not able to avoid it.

What decree of the Californian Law could authorize a magistrate to oblige a man to nudity to be photographed ?

The district attorney had still committed an abuse of power and so numerous and famous they are, the lawyers of the singer didn't have been able to avoid him this humiliation.

And when they learn a few days after this unchaste session that Thomas Sneddon broadcasted the video to his colleagues and investigators, making doubtful jokes on this "Wacko Jacko", the panic seizes them.

A penal trial will be fatal ...

There is hardly to bet that the boorish and strange personality of Thomas Sneddon precipitated the arrangement.

J.M. Creation

The press conferences of the district attorney are similar to a bad western, when the sheriff of the city exercises his law in the vulgarity, dishonest and compromise. It's a real manhunt and Jackson will finish executed by hanging !

The defense gave up even before a penal trial is envisaged.

Thomas Sneddon expresses himself too much. Thomas Sneddon stirs too much. Thomas Sneddon is even more vindictive than the father of presumed victim.

He has the Law, he knows how to manipulate. He is unstoppable.

And when, years later, we learn that Thomas Sneddon was at the origin of an investigation having gathered two Grand Jurys, auditioned more than two hundred witnesses, forty children, mobilized hundreds of policemen in the searches and appointed by investigators abroad with the aim of finding former employees of the star, for a two million dollar invoice imputed to the State of California, we can understand the apprehension of the jurists of Jackson.

Maybe only a lawyer like Thomas Mesereau felt strong enough to fight him. But wasn't he shivered when, in 2003, Thomas Sneddon exclaimed in front of the press "We hold him ! We finally hold him !, with a fat laughter, the day of the arrest of the singer ?...

J.M. Creation

Thomas Sneddon didn't really search for the truth.

And what demonstrates it in 1994 is this unthinkable instruction for two million dollars and... no proof.

With two hundred witnesses : nobody confirms the facts alleged by Jordan Chandler ...

See this example: here is the transcription of the testimony in front of the Grand Jury. It's from a bodyguard named Morris William, claiming to have surprised his boss with a young boy in a compromising situation :

- *What I know, I learnt it by listening to what others said.*

- But except these testimonies, you don't have any information about Mr Jackson and this boy ?

- *No, I don't.*

- Have you already spoken to a child who complains about the behavior of Mr Jackson ?

- *Never.*

- On what do you lean to say that Mr Jackson has an inappropriate behavior with some young boys ?

- *On the fact that I heard it in media and on what I saw.*

- Here we are, what did you see?

- *Nothing.*

J.M. Creation

In 1994, Thomas Sneddon finds nothing against Michael Jackson. After multiple searches, seizure of books, having viewed hundreds of video tapes, having peeled thousands of documents, letters and intimate correspondences, no proof. After having auditioned more than two hundred witnesses, nothing... An empty file...

But the strength of Thomas Sneddon is in the reign of fear. Although finding no confirmation of assertions against the star, he raises a carnivorous smile, giving the feeling to hide a joker in his sleeve. And his hatred is not played. He's really going to buy him, this cursed Jackson !...

For sure, the defense panicked. For sure, it threw in the towel.

A lawyer will never do anything against a prosecutor. He is at the same time representative of the Law and legislator. How to fight ?

So rich and covered of lawyers as Michael Jackson is not enough to take the part without damage.

And that time, in 1994, they all put off in front of this district attorney.

The arrangement intervenes just in time because nobody resigns to throw himself into the bullring...

J.M. Creation

But without these analyzed details, what to think about a man who lets burst an incredible and destructive scandal, a man who scrupulously follows every step of a judicial procedure, a man who unblinkingly accepts the searches, the seizures, the testimonies, the "medical examinations", a man who entirely undresses in front of strangers to prove his innocence and who finally pays his accuser to get through this nightmare ?

The only question is: why not to have made it from the very beginning ?

Stubbornness, again and again...

Obviously, Michael Jackson wanted to fight until demonstrate his innocence. But something intervened and stopped his moose.

In fact, we needed 11 long years to understand this step of the Chandler case. Only the penal trial that followed in 2005 will bring the answer through an official defense document : Michael Jackson has never paid his accusers !

On March 22nd, 2005, a certificate stipulates :

" The arrangement of 1993 was settled by the insurance company of Mr Jackson and without the approval of Mr Jackson.

The clauses of his contract covered any negligence and pursuits striking a blow at his career. The insurance

J.M. Creation

concluded the agreement and settled the arrangement, in spite of the protests of Mr Jackson and his personal jurists. "

J.M. Creation

1 | Thomas A. Mesereau, Jr. (SBN 91182)
 | Susan C. Yu (SBN 195640)
2 | COLLINS, MESEREAU, REDDOCK & YU
 | 1875 Century Park East, 7th Floor
3 | Los Angeles, CA 90067
 | Telephone: 310-284-3120
4 | Facsimile: 310-284-3133

5 | Robert M. Sanger (SBN 58214)
 | SANGER & SWYSEN
6 | 233 E. Carrillo Street, Suite C
 | Santa Barbara, California 93101
7 | Telephone: 805-962-4887
 | Facsimile: 805-963-7311
8 |
 | Brian Oxman (SBN 072172)
9 | OXMAN & JAROSCAK
 | 14126 East Rosecrans
10| Santa Fe Springs, CA 90670
 | Telephone: 562-921-5058
11| Facsimile: 562-921-2298

12| Attorneys for Defendant
 | MICHAEL JOSEPH JACKSON
13|

FILED
SUPERIOR COURT of CALIFORNIA
COUNTY of SANTA BARBARA

MAR 2 2 2005

GARY M. BLAIR, Executive Officer
Carrie L. Wagner
CARRIE L. WAGNER, Deputy Clerk

SUPERIOR COURT OF THE STATE OF CALIFORNIA

FOR THE COUNTY OF SANTA BARBARA

SANTA MARIA DIVISION

THE PEOPLE OF THE STATE OF CALIFORNIA,) CASE NO. 1133603
)
 Plaintiff,) MR. JACKSON'S MEMORANDUM IN
) SUPPORT OF OBJECTION TO
 vs.) SUBPOENA TO LARRY FELDMAN FOR
) SETTLEMENT DOCUMENTS
MICHAEL JOSEPH JACKSON)
) TIME: None Set
 Defendant.) DATE: None Set
) PLACE: Department SM-2
_____)

MEMO IN SUPPORT OF OBJECTION TO SUBPOENA FOR SETTLEMENT DOCUMENTS

J.M. Creation

A. **Introduction.**

Mr. Michael Jackson submits this Memorandum in support of his Objection to Subpoena of Settlement Documents from Larry Feldman. Mr. Jackson's Objection is based on the following grounds:

(1) Evidence of prior civil settlement agreement or amounts is irrelevant and inflammatory, and such evidence will destroy Mr. Jackson's right to fair trial with reversible error;

(2) The introduction of evidence of prior civil settlement agreements constitutes a violation of Evidence Code section 1152(a), cannot be used to establish state of mind, and do not show any type of admission;

(3) Plaintiff cannot establish the source of the funds utilized to settle the claims involved, and because insurance policies permitting the insurer to settle over the wishes of the insured were involved, introduction of settlement agreements will deprive Mr. Jackson of due process of law.

B. **Evidence of Prior Civil Settlement Agreement Is Irrelevant and Inflammatory.**

Plaintiff has subpoenaed a settlement document from a 1994 settlement in which Mr. Jackson compromised a civil claim filed against him by Evan Chandler, Guardian for Jordan Chandler. The settlement provides there is no admission of liability by any of the parties and that the settlement is designed to compromise negligence claims asserted against Mr. Jackson by the plaintiffs in a civil proceeding. Plaintiff seeks to obtain the settlement documents by way of subpoena for the purpose of introducing the document into evidence to establish some kind of admission against Mr. Jackson which not only does not exist, but also constitutes an impermissible inference of an admission against interest.

Mr. Jackson was not liable for any of the claims compromised by the settlement agreement, and plaintiff cannot present evidence of the nature, source, individuals, or companies who actually paid the settlement amounts evidenced by the settlement agreement. Because insurance companies were the source of the settlement amounts, and the insurance companies make the payments based on their contractual rights to settle the proceeding without Mr. Jackson's permission, the settlement does not constitute an admission and cannot be used to create such an impermissible inference to the jury. Introduction of the document would be improper because the settlement payment from a third party with the contractual right to make the settlement regardless of Mr. Jackson's wishes is irrelevant to any issue of this proceeding

MEMO IN SUPPORT OF OBJECTION TO SUBPOENA FOR SETTLEMENT DOCUMENTS

J.M. Creation

Evidence of insurance settlements not only deprives Mr. Jackson of due process of law, but also is an inflammatory violation of Evidence Code section 352 where no probative value exists. The speculative suggestion that Mr. Jackson somehow made an admission when an insurance company required a settlement, and in fact paid for the settlement, creates an impermissible inference to the jury that would deprive Mr. Jackson of due process of law.

C. The 1993 Civil Settlement was Made by Mr. Jackson's Insurance Company and was Not Within Mr. Jackson's Control.

The plaintiff seeks to introduce evidence of the civil settlement of the 1993 lawsuit through the testimony of Larry Feldman, attorney for the current complaining family and attorney for the plaintiff in the 1993 matter. The settlement agreement was for global claims of negligence and the lawsuit was defended by Mr. Jackson's insurance carrier. The insurance carrier negotiated and paid the settlement, over the protests of Mr. Jackson and his personal legal counsel.

It is general practice for an insurer to be entitled to control settlement negotiations and the insured is precluded from any interference. Shapero v. Allstate Ins. Co., 114 Cal. App.3d 433, 438 (1971); Ivy v. Pacific Automobile Ins. Co., 156 Cal. App.2d 652, 660 (1958)(the insured is precluded from interfering with settlement procedures). Under the majority of contracts for liability insurance, the absolute control of the defense of the matter is turned over to the insurance company and the insured is excluded from any interference in any negotiation for settlement or other legal proceedings (emphasis added). Merritt v. Reserve Ins Co., 34 Cal. App.3d 858, 870 (1973). An insurance carrier has the right to settle claims covered by insurance when it decides settlement is expedient and the insured may not interfere with nor prevent such settlements. 44 Am. Jur. 2d, Insurance, sec. 1392, at 326-27 (rev. ed 2002)

In Brown v. Guarantee Ins. Co., 155 Cal. App. 2d 679, 685 (1957), the court stated:

"It is generally understood that these are rights and privileges which it is necessary for the insurer to have in order to justify or enable it to assume obligations which it does in the contract of insurance. So long as recovery does not exceed the limits of the insurance, the question of whether the claim be compromised or settled, or the matter in which it shall be defended, is a matter of no concern to the insured." .

MEMO IN SUPPORT OF OBJECTION TO SUBPOENA FOR SETTLEMENT DOCUMENTS

J.M. Creation

PROOF OF SERVICE BY MAIL AND FAX

I, Maureen Jaroscak declare and say:

I am an attorney at law admitted to practice before all the courts of the state of California and I am an attorney for Mr. Michael Jackson in the above-entitled action. My business address is 14126 East Rosecrans Blvd., Santa Fe Springs, California 90670. I m over 18 years and not a party to the above-entitled action. On March 21, 2005, I served the following:

MR. JACKSON'S MEMO IN SUPPORT OBJECTION TO SUBPOENA FOR SETTLEMENT DOCUMENTS

on the interested parties by placing a true copy of the document in a sealed envelope, and depositing it in the United States Mail with first class postage prepaid at La Mirada, California, and addressed as follows:

Thomas Sneddon
1112 Santa Barbara Street
Santa Barbara, CA 93101
Fax No. 805 568-2453

In addition, on this same date, I served a copy of the document by fax to the above-indicated number by transmitting a true copy of it by facsimile pursuant to Rule 2003 of the California Rules of Court.

Executed this 21st day of March, 2005, at Santa Fe Springs, California.

Maureen Jaroscak

MEMO IN SUPPORT OF OBJECTION TO SUBPOENA FOR SETTLEMENT DOCUMENTS

Court transcriptions (extracts) 2005

J.M. Creation

So, his insurance companies put an end to this judicial battle and stupidly left his insurant in nauseous suspicions of guilt.

We know today that Jordan Chandler has never seen his mother, June, since 1994; that he was emancipated in 1995, literally abandoned by his father, Evan.

We also learnt that, in 2005, during the trial, he left the USA not to testify against Jackson.

News also mentioned a complaint emanating from Jordan against his father for voluntary violence in 2006.

According to the complaint deposited in New Jersey, Jordan accuses his father of having assaulted him, striking him in the head, having neutralized him with a teargas and trying to strangle him.

We can also mention that this arrangement allowed him to acquire a property in Long Island, an apartment in Manhattan and another one in Los Angeles.

He would besides have requested for a change of identity.

Michael Jackson's pugnacity was annihilated in January 94 without offering him the slightest chance of repartee and leaving him in an abyss of biased insinuations that will never leave him...

J.M. Creation

The consequences of the settlement

At this beginning of 1994, the Chandler case goes out by a mutual agreement causing the end of the civil procedure.

This arrangement also compromises the legal proceedings because in return of the financial compensation, Chandler gives up testifying in front of the Grand Jury.

Although continuing some time, the instruction was enclosed for insufficiency of proofs.

In spite of the considerable efforts of Thomas Sneddon, the charge finds no other witness for the prosecution, gets lost in the hypothetical and the district attorney, deprived of his "friend", Jordan, has to abandon the pursuits.

His hatred intensifies so that he legislates to modify the Californian Law in such a case.

So, since 1994, no witness can refuse to testify in the penal, including in case of civil settlement.

J.M. Creation

Thomas Sneddon leaves the door opened to any new complaint by freezing the instruction without enclosing the file, even launching an appeal for witnesses to take back the investigation.

Bitter and deprived by this unexpected conclusion, he doesn't stop expressing himself publicly, swearing the guilt of the singer.

We note that he gave then interviews in New York Times, Showbiz Today, The Chattanooga Times, The New York Beacon, The Advertiser, The Daily News, Broadcast News, The Herald Sun, The Daily Telegraph and Vanity Fair Magazine, permanently back on the Chandler case in spite of the investigation secrecy and, that over the years and until 2003, he maintained the doubt and pursued his hunting in witnesses.

No, he doesn't enclose the file. He makes reference to this file, appointing it "opened but inactive ".

He just waits for a new victim ready to cooperate who would allow to open again the investigation, according to his own statements.

In 1994, Thomas Sneddon still "feels hungry", angry and more definite than never.

"Wacko Jacko" can't get out of this so easily !

Rumors circulated, the district attorney would have elaborated a plan during a dinner to get rid of Jackson to Santa Barbara by finding another child accusing him of sexual abuses.

J.M. Creation

For sure, Thomas Sneddon got ready to take the slightest opportunity... He will need 11 years of patience to quench his vengeance...

From his part, Michael Jackson lets fall the excitement and takes refuge in silence.

The settlement contains a clause of confidentiality : both parties will never have to publicly evoke this dispute.

Two years after its conclusion, the star vaguely gives his feeling and explains why he preferred to pay :

" I wanted to pursue my life. Too many people suffered. I want to make records. I want to sing. I want to perform... It's my talent. My work. My life. My decision. "

He laconically adds he also wanted to check the **" media circus "**.

When he concluded this allusion, Evan Chandler lodges a new complaint against him.

He accuses him of having broken the written agreement to never evoke the case and deposits a 60 million dollar request of damages.

For information, the court will rule in the favor of Michael Jackson in 1999, by refusing Evan Chandler request.

J.M. Creation

For this motive, in 2002, in front of Martin Bashir, director of the sinister report " Living with Michael Jackson" - that will directly drive him to Court - who asks him what he felt in 1993, he answers :

" I was shocked but I'm not allowed to talk about it by law. "

He didn't lie. He didn't elude the question. He just didn't want to pay again and again Evan Chandler !...

J.M. Creation

The FBI files

Conclude the Chandler case without evoking the official FBI files revealed in December 2009 is impossible.

We notice that, in spite of the instructions of the district attorneys of Los Angeles and Santa Barbara, a parallel FBI investigation was sought.

No doubt that Thomas Sneddon wasn't stranger to this request ...

Put online on the official FBI website, they appear under the shape of seven different files, covering all the assertions against Michael Jackson from 1992 till 2005.

It's incredible to notice that even FBI detained no proof against him. These files are empty and sometimes despicable of such an institution, annexing absurd documents like tabloids articles or sordid assertions of former employees - more avenging than tangible.

17 years after the facts, it seems that even FBI couldn't provide a slightest evidence of his guilt.

J.M. Creation

274 pages constitute the investigation during the Chandler case.
And this file is very surprising ...

In September, 1993, LAPD seeks the assistance of FBI in the investigation against Michael Jackson in connection to the assertions of abuse on minor.

The said motives are: " *a possible violation of the federal law in transport of minor outside the State for immoral reasons.* "

The answer of FBI to this request is hurtful : after analysis, they refuses to investigate for those motives and insists on the fact that no meeting with the district attorney will be scheduled.

This file contains the copy of the LAPD report drafted in the name of Michael Joe Jackson, mentioning no charge against him but evoking his implication in a traffic accident in Santa Barbara, on April 21st, 1991.

Is it there the reality of his meeting with June Chandler ? There is hardly to bet ...
The copy of his driving licence expiring in 1989 is also passed on to FBI in October, 93.
Does this mean that the police was only worrying about an expired driving licence ?...

J.M. Creation

A new report treats assertions. What we can name "notes of investigation " are annexed. They are diverse and varied, evoking toys sent to Australia, recording two plane tickets for Philadelphia, some American Airlines documents, returning on the attempts of extortion Michael Jackson knew before.

It also mentions the investigation led by the LAPD in September, 93.

Detectives are appointed to find and question the former employees of the singer, living in Manilla.

"To assure" the utility of this initiative, FBI leans on articles, joined to the file, and especially one from the " Philippines Star ", telling the story of this couple, former domestics, who claims to have seen him " caressing young boys ".

Absurd to find tabloids in a so official file as that one !

Then, in the same funny plan, a London Daily Mail article, telling the story of a young 13-year-old fan allegedly harassed by phone by Jackson, appears in this FBI investigation.

With a letter from London American Embassy , it's stipulated "that no particular action is planned and that it's only simple information ".

In fact it turned out that this boy pursued Jackson during years, bombarding him with phone calls which he systematically declined, desperately trying to meet him during his stays in London.

Embittered by his indifference, the boy - then become adult - had decided to take revenge by appearing at the press to charge Jackson.

J.M. Creation

This file clearly shows that LAPD tried to get back these assertions to strengthen their charges.

An internal correspondence sent to the New York FBI office wonders about the obtaining of a warrant against Michael Jackson.

The answer of the New York office on October 19th, 93 is without ambiguity : the agents of New York have no charge against him.

Two testimonies collected by LAPD and deposited in September, 93 follow in these FBI reports.

First of all, a writer investigating the customs of the star, drafting "shocking revelations " on Michael and the young children.

He told LAPD that FBI covers Jackson since the middle of the 80s, having proceeded to an investigation and found that he had molested two young Mexicans.

He claimed that he had benefited of a kind of "immunity", having met the president of the United States.

The second testimony is the one of a steward having assisted Jackson and his team during a train trip. According to her statements, " Jackson had shown himself very possessive the night with a kid presented as his cousin ". The file stipulates : " this employee was worried enough about the situation to refer to the driver " !

Finally, finding no tangible element, no convincing testimony, no irrefutable proof, FBI closes the file in 1994.

J.M. Creation

Even if FBI specifies that LAPD pursues their investigation in "the expectation to charge Michael Jackson ", they stop their participation.

We notice that in the 90s, California tempted everything "to catch" the star in these assertions of abuse.

The police of Los Angeles seriously pursued Jackson and, if such wasn't the case, would they have asked help to FBI ?

The federal office tried well to support LAPD but quickly collided with... nothing.

They had been more effective in 1992 when they intervened for threats of death against the star, real threats this time.

Indeed, a report about an investigation ended by the arrest and the imprisonment of an individual having uttered written threats of death against Michael Jackson and George Bush.

But there, in this story of abuse, nothing !

Just testimonies from former dismissed and vindictive employees or from disappointed fans ... No testimony confirming the facts expressed by Jordan Chandler, able to justify legal proceedings.

Faster than district attorneys of Los Angeles and Santa Barbara, FBI classified this affair, convinced of a single fact : nothing demonstrated his guilt. Closed file.

J.M. Creation

We learn however that FBI proceeded to a new investigation in 1995, during the seizure by the West Palm Beach customs of an entitled video tape "Michael Jackson Neverland Favorites Boys".

This pornographic recording was analyzed by the services but no direct link was established with Jackson. It was a tape edited in number, "surfing" on assertions, and delivering a neutral porno contents.

This investigation shows the aftereffects that will undergo the star till the end of his life, and even later : the lack of respect, irony, mockery, insult and rudeness that are now addressed.

The shadow of the criminal that accompanies each of his steps, eats his life away and makes his name dirty.

Without surprise, we discover in these archives that in January, 2004, the sheriff of Santa Barbara addresses again FBI and requires a warrant for the seizure of computers and diverse objects.

A new Jackson file is then opened. A new investigation to constitute empty notes as the previous ones.

This initiative will end this time in a four months penal trial in 2005 that leads to the acquittal of the artist, on June 13th, 2005.

Everything was played beforehand : after the meticulous examination of these 16 computers seized in Michael Jackson's residence, FBI had already found... nothing.

J.M. Creation

But judicial doggedness obliged them to pursue their collaboration to find a slightest fault.

Sure that Thomas Sneddon and his team desperately looked for this fault and that they had their revenge to take on the settlement concluded in 1994 ... Sure that the district attorney of Los Angeles, the LAPD, the sheriff of Santa Barbara, the district attorney of Santa Barbara and the FBI were not still sufficient to "catch this pervert" !...

No, no, there was no doggedness, no vendetta !...

J.M. Creation

And... ?

May I allow myself a more personal conclusion ?...

I've never believed in the guilt of Michael Jackson in these dirty cases.

Not because I appreciated his art but simply because I didn't discover the facts in June 2009...

It's not the premature disappearance of this gifted artist that engendered the curiosity. I lived - from far - the Chandler case from day to day in 1993-94, with all those rumors, sulfur and excess.

Assertions were rickety from the beginning. They didn't add up. They didn't stick on the character and did just appear an attempt of extortion.

Michael Jackson never entered the stereotype of the star of show business. His universe wasn't the classic "Sex, Drug and Rock 'n' Roll ". This artist is atypical.

J.M. Creation

He never had stuffed with sulphurous events, he didn't show his success but shared it. He has never given a decadent image inspiring bad example, as a lot of celebrities. No, he was the exact opposite of "Sex, Drug and Rock 'n' Roll "...

Kind icon who wanted to be wise and pious and controlled his impact on the public ...

Michael Jackson's psychology is at the origin of grave misunderstandings.

He wasn't really responsible and didn't even knew how to defend himself from this. But some took advantage of a shape of naivety and were incensed.

"Bambi" was kind, full of illusions, good feelings and hope. Profoundly pacifist, he loved the world and from the bottom of his heart, wished to relieve the suffering.

No other artist has so much contributed to the humanitarian level. We attribute him now more than 400 million donations to diverse charities.

His ideology, maybe fanciful for some, was more similar to a Gandhi than to a sexual predator. This time, it's not him who showed perversity but the whole world that was incensed during decades against a man, when everything demonstrated him innocent !

J.M. Creation

He underwent the gibes, mockeries, insults and even indecency without ever riposting and by persisting in his fight for world peace. He would have been able to give up and turn away from this despicable world that incriminated him. But, always furious and definite, he didn't bend and continue to move on the road of the harmony of human race.

It was his only freedom : to pursue this mission he felt invested.

He gave a sense to his life and offered to others the opportunity not to know what he suffered.

Michael Jackson was incapable of ill-treatment because he was its produce.

Victim in the childhood, victim in the adolescence, he just knew some years of respite before becoming again a victim of the world at the age of 34 years. We say that a victim is forever a victim, it was his case ...

But this artist was only lunar, idealistic. The path is showed to millions of people throughout the world is the one of humanity. Show heart to heal the misfortune. He dreamed about happiness and unity. Is there dream that deserves punishment ?

The Michael Jackson statements and speeches clearly reflect his psychology. He only looked for love by taking refuge body and soul with the faith.

J.M. Creation

That's why, he was so unique. That's why he seemed so different. A child in man's body hurt by the cynicism of an adult world, victim of plots he didn't understand and that destroyed him.

Michael Jackson was not made for this icy, indifferent and damaged world. He dreamed about a better world. The world took him the best to empty him of any feeling.

Yes, he wasn't made for this world ...

To end on the affair treated throughout these pages, I'll wish to insert here a text, written in 2005 by Jacob Weisberg, editor of a website named Slate.fr.

This article perfectly reflects my own thoughts and comes in ideal conclusion, applying to a misunderstood and mistreated man.

" I have never believed in Michael Jackson's pedophilia.

First of all, he doesn't correspond to the profile of the pedophile. The persons abusing children tend to act in the same way, again and again. A study shows that the persons who sexually assault boys commit 280 offences in their life. Now today, in spite of the lure of gain which would engender such charges against Michael Jackson, only two presumed victims appeared with detailed assertions.

J.M. Creation

These two charges, separated from 10 years, don't correspond to a model. To speak frankly, in the most recent case, the accuser - victim of the cancer - declared to have been fiddled by Michael Jackson. The previous plaintiff, whose family perceived in 1993 twenty million dollars of damages, accused the singer of more extreme sexual abuse, and spoke in particular about something oral-genital.

But the reason why I've never believed in the description raised by the district attorney, who made of Michael Jackson a sexual, active predator in a deliberate way, "preparing" his victims, is the fact that it doesn't match with psychological point of view. If he has yes or no touched a boy in a inappropriate way, Michael Jackson seems too emotionally fragile to act as an adult, even less as a sexual deviant.

Naïve, young, and profoundly bruised, he seems pathetically incapable to show the slightest criminal intention, but also any adult thoughts.

People tend to make it too much about his strange behavior or his multi-facets character.

But is it strange ?

Child, from the age of seven years, he was forced to work by a cruel and violent father. (If he had been sent to a factory or

J.M. Creation

a coalmine instead of going on stage, we would have more condolence towards him).

Child, he was deprived of what even the deceived or discriminated children can have : school, friends, games.

Instead of it, Michael was transformed into an artist sexually disturbing, a boy with a voice of soprano that aroused the passion of the women.

He was transformed into a witness of the sexuality of the adults at an age where it was only terrifying and incomprehensible for him.

At the age of 10, he occurred in clubs of striptease and hided under the covers of hotel rooms whereas his older brothers rose with groupies.

In 11 years - the age when his psyche seems to have been congealed - he was a superstar.

" My childhood has been completely stolen ", he confided. Almost all that seem abnormal can be explained by his touching but desperate attempt to find his stolen childhood.

J.M. Creation

It's not really fair to describe the world Michael Jackson created around him as a youth fantasy. With help of his health and celebrity, he was able to live as a retired child.

By means of the plastic surgery, he made of him a pre-pubescent teenager. He has fun with luxury toys, extraordinary pets, walks in his amusement park and enjoy the magic.

What stood out during the trial (2005) wasn't the image of a man playing with children to seduce them. It was the image of a man playing with children because he saw himself as one of them. He and his "Apple Head Club" friends remained awake all night long, playing video games, watching TV and eating popcorn.

In the absence of any parental authority, they would have sometimes drunk some wine in Coke cans, would have made some phone hoaxes, read obscene magazines...

Child in the head, Michael Jackson sees his behavior totally innocent. It was an evening pajamas; it had nothing to do with seduction.

He confided to Martin Bashir, the English director of the "Living with Michael Jackson" documentary (2003), he specifies, in a way that seems sincere, that he sleeps with young boys only by love, and not for sexual reasons.

J.M. Creation

Michael Jackson seems not to be able to understand enough the sexuality of the adults and see why people lent him more sinister intentions.

There is here, obviously, a previous literary example.

"*I'm Peter Pan*", he confides to Bashir.

In the ranch of Neverland, as in the Nursey Darling, the boys sleep all in the same room. Michael, as Peter, is the father, the older brother and the leader. He leads the lost children towards stampedes and adventures.

This comparison between Jackson and the author of this tale, J.M. Barrie, is maybe more interesting.

As Jackson, Barrie suffered from an interrupted growth bound to the death of his older brother when he was six years old.

According to Andrew Birkin's book, " J.M. Barrie and the Lost Boys: The Real Story Behind Peter Pan ", Barrie's marriage was never consumed and his deepest relation was with the Llewelyn Davies brothers, five boys he met at Kensington Gardens in London and who inspired the Peter Pan characters.

Barrie played with the children, more or less lived with them and dreamed to share the bed with them. There's no proof of

J.M. Creation

physical relations. The most likely hypothesis is that Barrie was a single man and asexual.

Today, we find the idea of no sexuality stranger than a deviant sexuality.

But in the case of Michael Jackson, it seems more likely than quite other explanation.

The strange behavior of Jackson seems to be the consequence of the fact that he underwent child.

Tortured by his father, he became extraordinarily kind and generous with the children.

Terrified by the sexuality of the adults, he shut himself in a pre-adolescent immaturity.

"*I was never betrayed and deceived by children* ", he declared.

"Adults have forsaken me."

Jacob Weisberg

Slate.fr

J.M. Creation

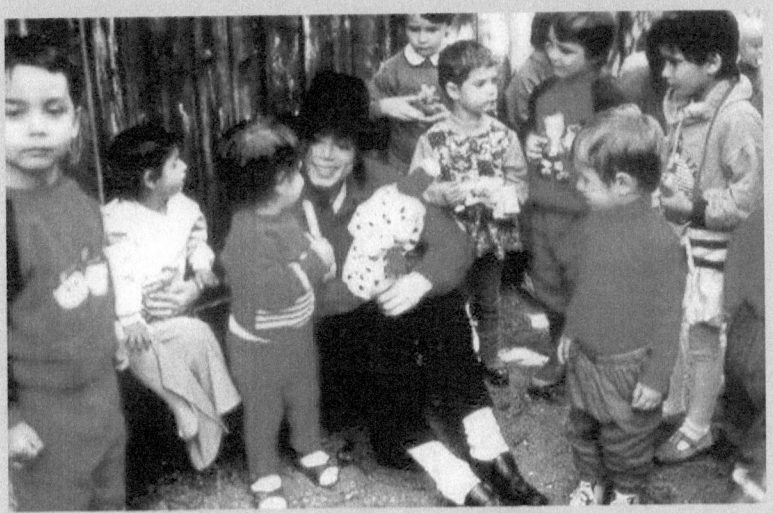

J.M. Creation

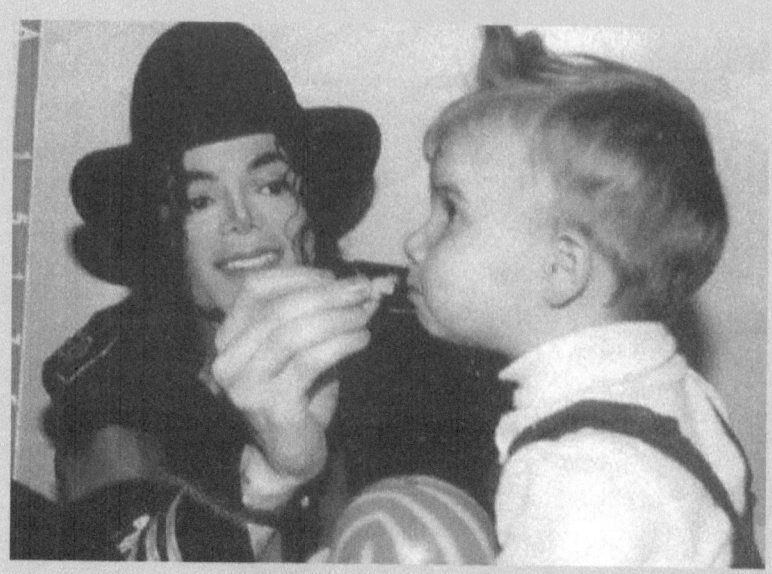

J.M. Creation

J.M. Creation

J.M. Creation

By purchasing this ebook, you have supported the MJ Children Foundation, founded by the author of this book.

A share of the profits will go to MJ Children.

If you don't know this humanitarian organization, you should know that we created MJ CHILDREN to follow the footsteps of Michael Jackson in the humanitarian field. Our involvement is a duty to remember, respect and commitment. In this spirit devoid of any personal motivation, we try to change some injustices and work towards a better world.

The goal of MJChildren is to help children in need around the world.

Its role is to bring people aware of all forms of suffering and disability of children worldwide.

MJ CHILDREN proposes to collect donations and membership of international members in order to redistribute these funds to large and famous organizations.

These organizations, MJ CHILDREN partners, are designed to assume the sponsorship of children in the world and meet all their needs. The field of action is the creation of nurseries, clinics, orphanages, schools, facilities for drinking water, emergency kits (food, school supplies, baby hygiene, house ...) wherever it needs.

In continuation of Michael Jackson efforts for years, we wish to bring many to help these people. Childhood is the future of the planet, we act in the sole purpose of solidarity and mutual assistance.

J.M. Creation

J.M. Creation

« Michael Jackson : What his HATERS don't WANT to KNOW ! »
© 2010

Jacqueline Marie

Copyright depot.com
Droits d'auteur
cliquez pour vérifier
00047957
http://www.copyrightdepot.com/cd2/00047957.htm

Contact writer

Any modification or duplication of this document will be liable to prosecution.

Reproduction, in whole or in part, without permission is prohibited.

All rights reserved.

www.ingramcontent.com/pod-product-compliance
Lightning Source LLC
Chambersburg PA
CBHW020545220526
45463CB00006B/2203